VRamia

A tale of our times
with (hopefully) some
hope for us all

SIMON & SCHUSTER
New York London Toronto Sydney

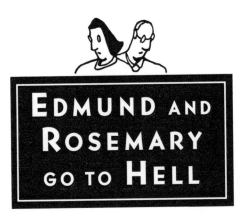

EDMUND AND ROSEMARY GO TO HELL

BRUCE ERIC KAPLAN

SIMON & SCHUSTER
Rockefeller Center
1230 Avenue of the Americas
New York, NY 10020

First Simon & Schuster hardcover edition May 2007

SIMON & SCHUSTER and colophon are registered trademarks
of Simon & Schuster, Inc.

For information about special discounts for bulk purchases,
please contact Simon & Schuster Special Sales at
1-800-456-6798 or business@simonandschuster.com.

Designed by Kim Llewellyn

Manufactured in the United States of America

10 9 8 7 6 5 4 3 2 1

Library of Congress Cataloging-in-Publication Data TK

ISBN-13: 978-1-4165-4549-1
ISBN-10: 1-4165-4549-2

This book is for
anybody that is in
pain about anything, and
that means you.

It was a Sunday afternoon, and

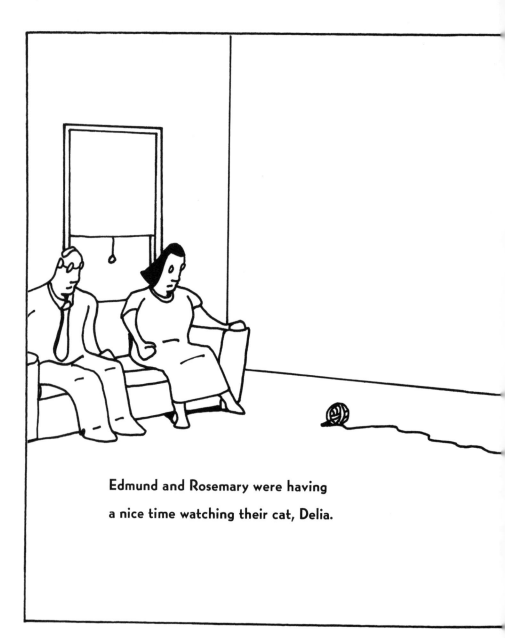

Edmund and Rosemary were having

a nice time watching their cat, Delia.

Pets are so interesting, even though

they never really do anything,

which is the exact opposite of people.

Edmund and Rosemary decided to go
for a walk around their neighborhood,
in Brooklyn.

Immediately, something terrible happened.

A woman was right in

front of them

TALKING

LOUDLY

on her cell phone.

Rosemary wanted to

briskly pass her, but

she couldn't, because

the loud woman was not really

paying attention to anything

other than her phone call.

She lumbered

on slowly,

blocking

Edmund and

Rosemary's

way.

Finally,

they got by the loud woman.

 Rosemary scowled at
her, but of course the woman
didn't notice, which made Rosemary
even madder. There is nothing
worse than an ignored scowl.

"I don't know why everyone's
always on a cell phone,"
Rosemary said.

Edmund said not everyone was
always on a cell phone. But
then he looked around and

had to admit that

indeed everyone was.

"Cell phones make life so much more
unpleasant," said Rosemary, and sighed.
Edmund sighed, too. He always had to sigh
if someone else did. They decided to go
to the movies.

They ran through the streets,

trying

to avoid

all the

people

on their cell phones.

2	MISSION TO JUPI
3	BLASTOFF
4	GROSS GUYS
5	DEATH EXPLOSI
6	SOME OLD TV SERI

When they finally got there, they couldn't decide what to see, since each movie seemed to be so unintelligent and incomprehensible and simply not fun.

They realized that for years they had been going to the movies out of habit, denying to themselves how horrible movies had become.

As they walked home, Edmund said, "Come to think of it, music has become wretched, too. And theater. And art. Art hasn't been good for at least fifty years."

"Art really stinks," Rosemary agreed. "The Pop movement was particularly stupid." It felt good to finally say it out loud.

Of course, television was also dreadful, the worst part being the people on the news shows screaming at each other.

"Why do these TV people have to yell at us with their big bright teeth?" Edmund demanded to know.

It occurred to them that the problem wasn't just cultural. As if Edmund and Rosemary had suddenly woken up from a dream,

they noticed that everything around
them had become terrible.

Teenagers now were

all

violent,

crazy

drug addicts,

always

doing

nine million

things

at

once.

Whenever you called any business
whatsoever, you heard a strange
automated voice on the other
end of the telephone.

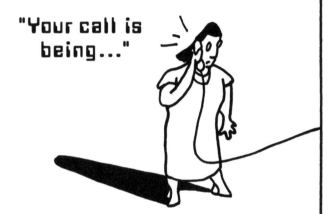

"Your call is being..."

Those creepy telephone robots
were very upsetting.

There were no more nice stores, only

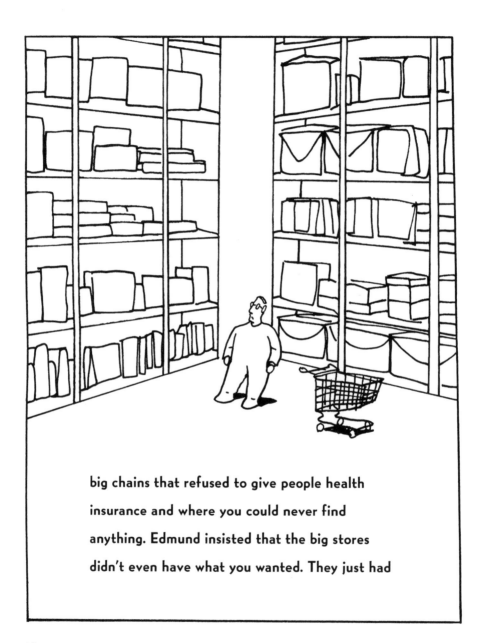

big chains that refused to give people health

insurance and where you could never find

anything. Edmund insisted that the big stores

didn't even have what you wanted. They just had

more

of

what

you

didn't

want.

$8\frac{1}{2}$ by 11 3 HOL

$8\frac{1}{2}$ by 11 3 HOL

$8\frac{1}{2}$ by 11 3 HOL

$8\frac{1}{2}$ by 11 3 HOL

$8\frac{1}{2}$ by 11 3 HO

$8\frac{1}{2}$ by 11 3 HO

$8\frac{1}{2}$ by 11 3 HOL

$8\frac{1}{2}$ by 11 3 HOL

No one built

nice houses anymore.

There were just ugly monstrosities

that took up all the land.

People all sit around

in coffee shops,

saying

they're

writers.

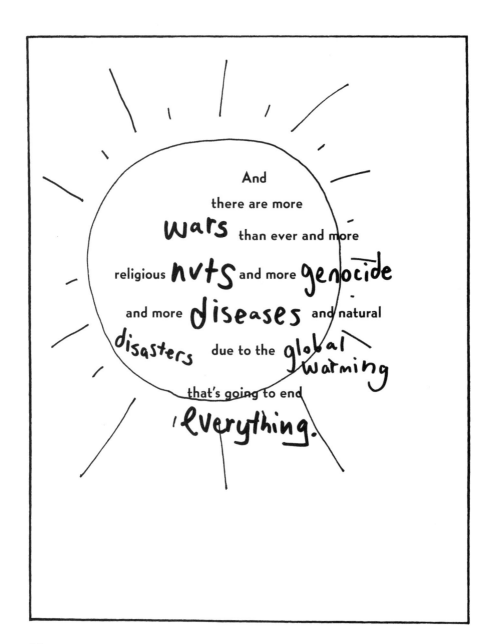

And there are more **wars** than ever and more religious **nuts** and more **genocide** and more **diseases** and natural **disasters** due to the **global warming** that's going to end **everything.**

Worst of all, perhaps,

there was the

traffic.

"Not that you want to go anyplace, but, if you did,
you wouldn't get there because of the traffic,"
Rosemary said, now infuriated.

"This is why I'm always saying we should live in
the middle of nowhere."

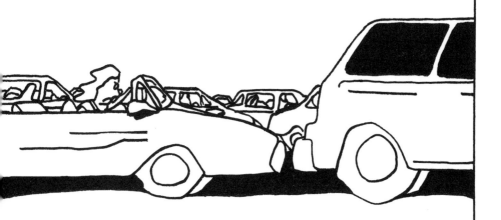

Rosemary pointed out that even in the middle
of nowhere, where there was nothing and no one,

there was still traffic.

They were silent for a moment.

"Some food is still good," Edmund said.

"I guess," Rosemary said.
"But they've ruined it by saying
that everything is not healthy in
some way. Even the things that are
good for us are covered in

pesticides and
toxins or filled
with hormones."

"What about organic food?"

"Organic food is a total lie
and you know it," she said
firmly.

And Edmund did
know it. Like
everything else,
organic food
had been co-opted
by the corporations, which
were utterly and completely evil.

"We are in hell," Edmund said.

"I think maybe we should try to
be less negative," Rosemary said,
but didn't really mean it.

"No, listen to me." Edmund was
having one of his epiphanies.
"There is only one explanation
for why everything is so terrible.
We are in Hell, the place."

"Oh, please, why would I be in Hell? I'm a good person."

Edmund listed a few things that Rosemary had done that could have made her eligible for Hell.

THINGS ROS[

1. She told (

2. She said s

3. She was c

Rosemary said if they were in
Hell wouldn't they know it?

"I do know," he said. "We
are."

Rosemary ignored him
and went to sleep.
The next day,
Edmund seemed
out of sorts.

She asked him what was wrong.

"I'm very depressed about
being in Hell."

Rosemary said,
"I have to go get
my computer repaired."

At the store, the little technician
scoffed at how old her computer was.

"I just bought this three years ago,"
she said.

The technician explained that that was
old now. "Nothing lasts longer
than three years."

Rosemary remembered how
her mother had had the
same vacuum cleaner
for her entire
adult life.

Rosemary got teary and
turned to Edmund. "It's true.
We really are in Hell."

"Really?" he said, delighted
he was right, but sad
about being in Hell.

She looked around and said, "We
must have done something really
bad to have ended up here."

Edmund spent the rest of the
week being somewhat elated
at finally giving words to a
feeling he had long had.

Rosemary was more unsettled
and went inward.

"Why aren't you going to your book group?"

he asked one night.

"What's the point? Those women

are really Hellish."

Edmund couldn't disagree.

One horrible day, Edmund and

Rosemary had to go out to

New Jersey

for a family occasion at Edmund's
Uncle Donald's house.

The deadly event went on for hours
and hours. Someone asked Edmund
what was new and he tried to tell
his whole family how they were in
Hell.

People thought he was

making a bad joke

and Edmund felt

misunderstood

by those who

were supposed

to be closest

to him, as

he always

did.

Rosemary felt bad for Edmund and told
everyone he was serious. They got mad.

His cousin Carol said she
was going through some
really heavy stuff
right now and
didn't need to
be told she
lived in Hell.

And Uncle Donald
said simply,
"Edmund, my boy,
you're overthinking this."

This made Edmund very upset.
As we all know, what's the point of
anything unless you overthink it?

People took Rosemary aside and told
her they thought Edmund was crazy,
as they always did at these things.

That night,
Rosemary
began to have
doubts about
Edmund's revelation.

"If it *is* true,
then we should
be able to get some proof."

Edmund argued, "Everyone proves everything and then it's always disproved."

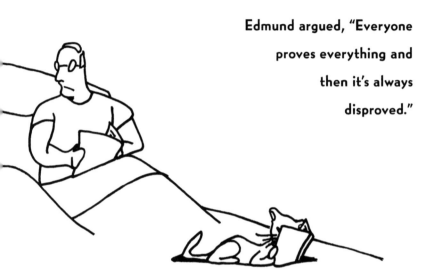

But Rosemary insisted, so

they decided to go to the government.

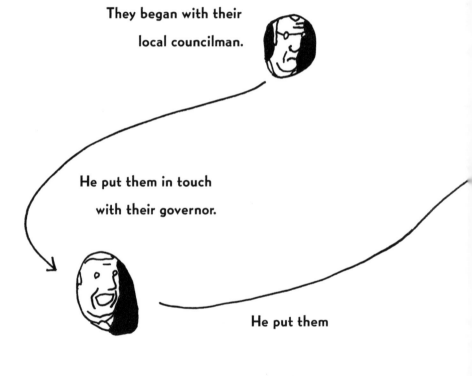

They began with their local councilman.

He put them in touch with their governor.

He put them

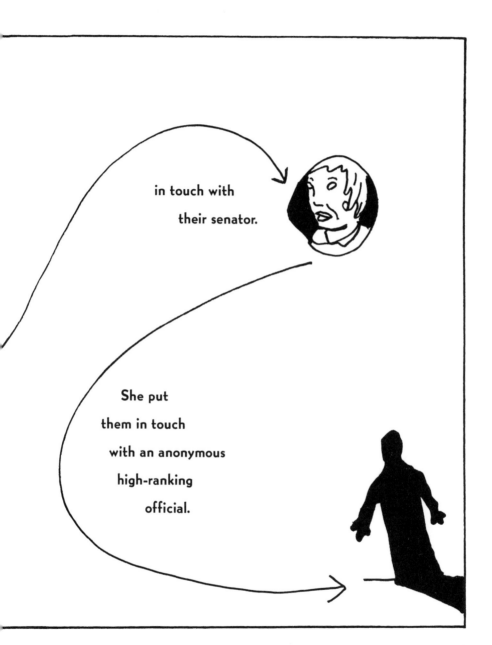

in touch with
their senator.

She put
them in touch
with an anonymous
high-ranking
official.

They met with him in

Washington, D.C.,

which was just as muggy

as everyone said it would be.

He denied any reports that this was Hell, as
Edmund and Rosemary knew he would, because
the first instinct of all politicians is to lie.

They applied some pressure

and finally he squawked,

because he

was a

spineless

little

weasel

like all

politicians,

even the ones

who act as if they're

not.

"Yes, this is Hell," he said.
He told them everyone in
the government was in on
it. That was why they
were always so

slow and

annoying.

"I want to give you something,"
said the anonymous high-ranking
official, and handed Edmund
an envelope.

Edmund quickly gave it
to Rosemary to open,
in case it was a bomb.

It wasn't.

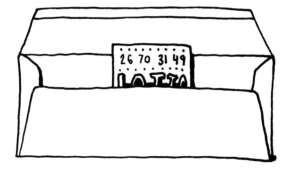

It was a lottery ticket. Rosemary
looked at it curiously.

"That's what we do when people find
out they're in Hell."

"They win the lottery?"
Edmund asked.

He nodded. "We don't like this Hell
stuff to get around. Bad PR, you know.
This ensures you won't talk. You'll get
your 342 million by the end of the week.
Now, if you'll excuse me,

Edmund and Rosemary were
exhausted when they got home.
There's nothing more tiring than
knowing the truth.

Five days later, they won

the lottery. At first,

they

had

some

fun

with

the

342 million.

Then

things went back to normal,

as, sadly, they always do.

Knowing without a doubt

that they were in Hell

sometimes made Edmund and

Rosemary a little edgy.

Edmund sought solace

in exercising maniacally,

while Rosemary drank more,

as was her way,

but neither activity helped.

One night, Edmund came home

from the gym, put down his

stupid little gym bag,

and began to weep.

"This isn't working," he said.

Rosemary slurred something
that he didn't quite hear,
but he took it that
she agreed.

"We could try religion,"
he said halfheartedly.

"Religion is stupid,"
Rosemary said.

Then they remembered that

Rosemary's friend Beth went

to a hypnotist who she

swore was a

genius who

could do

anything.

They went to see him and said

they wanted to forget the fact

that they were in Hell.

After four appointments,
they both still felt edgy
and gave up
on hypnosis.

Rosemary commented that
whenever anyone says someone
is a genius who can do anything,
it means he or she is an idiot
who can do nothing at all.

They tried therapy.

They went to a

Freudian therapist.

Then a

Jungian.

Then a
behaviorist.

And so on.

None of them could help, although
all of them insisted they were
really helping.

In desperation, they went to a breathing
workshop, which was embarrassing,
because they had both been breathing
for quite some time without one.

In the middle of the workshop,
Rosemary started looking around for
the exit. She often did this halfway
through any situation.

Suddenly something dawned on
her. She turned to Edmund.
"There must be a way out."

"I think it's over there,"
he said.

"No, I mean somewhere in
Hell there must be an exit
and we can get
to
Heaven. I'm
sure of it. It's just a
matter of finding out where
it is and going there."

Edmund sighed. He hated traveling.
Which was something that had always
grated on Rosemary. But in this case,
he really didn't have a choice.

When they got home, Rosemary
did a little research and twenty
minutes later, she came back.

"You can get to Heaven from
someplace out in Arizona,"
she said.

He sighed again. "Well, let's go,"
he said, glad they didn't have to
go to another country, where

he might have trouble with
the water.

"I've got to figure out what

to wear," said Rosemary, which

was confusing, because she needed

to dress for both Arizona and Heaven.

The airports were a

disaster and, of course,

provided the most proof of all

that they were in Hell.

When, finally, they arrived in Arizona, Edmund and Rosemary felt very alienated.

There were so many ugly T-shirts.

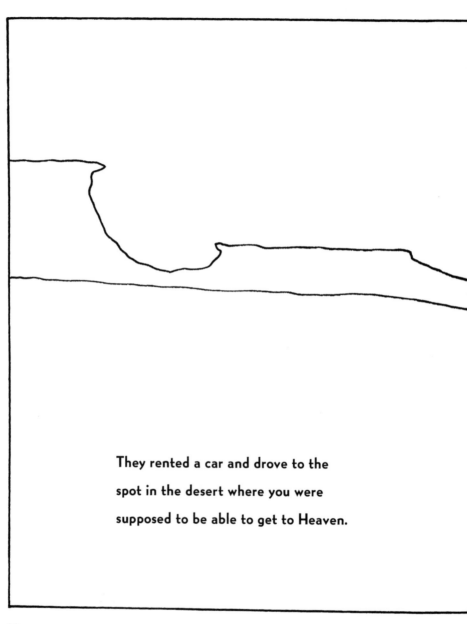

They rented a car and drove to the
spot in the desert where you were
supposed to be able to get to Heaven.

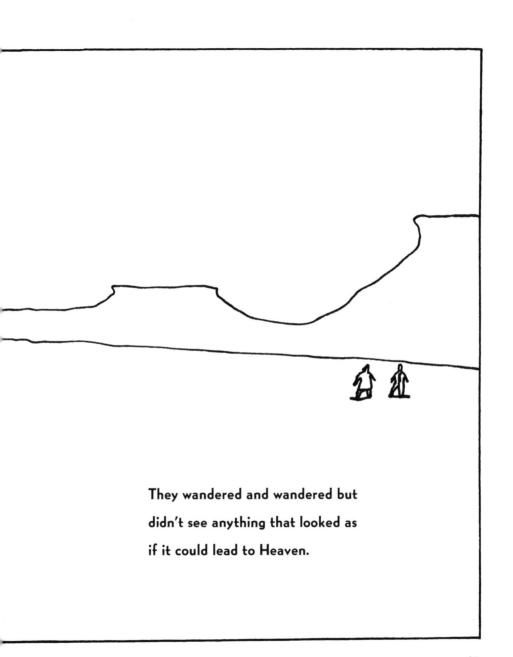

They wandered and wandered but
didn't see anything that looked as
if it could lead to Heaven.

"Didn't the Web site say it would be clearly marked?" Edmund asked.

"Oh, everything on the Internet is a crock," Rosemary said, and

plopped herself down on a rock in defeat.

"Why did I believe there was going to be
an exit to Heaven in Arizona?
This is all your fault."

Edmund was silent. He knew that sometimes
Rosemary needed to blame him for everything.

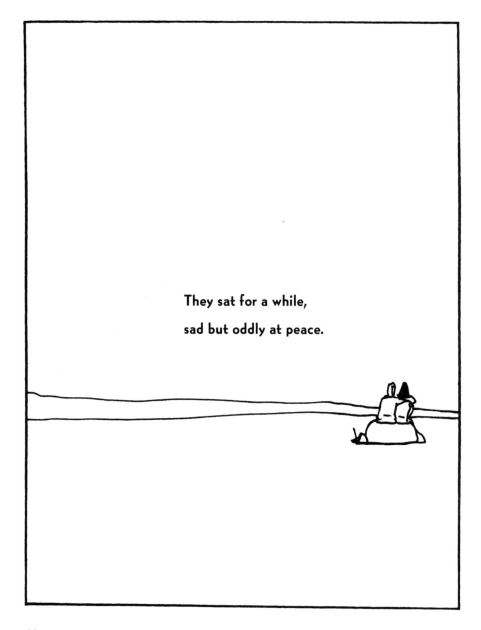

They sat for a while,

sad but oddly at peace.

Then a group of people from
a resort walked by, obviously
on a hike. They were a rich,
pampered lot, clutching
their water bottles.

Their group leader stopped and asked
Edmund and Rosemary if they were lost.

"Actually," Rosemary said
very casually, because
she knew that no one ever
gives you what you want
if they know you really
want it, "do you happen
to know how we can get
to Heaven?"

"Oh, they moved that," she said.

Edmund snorted unhappily and

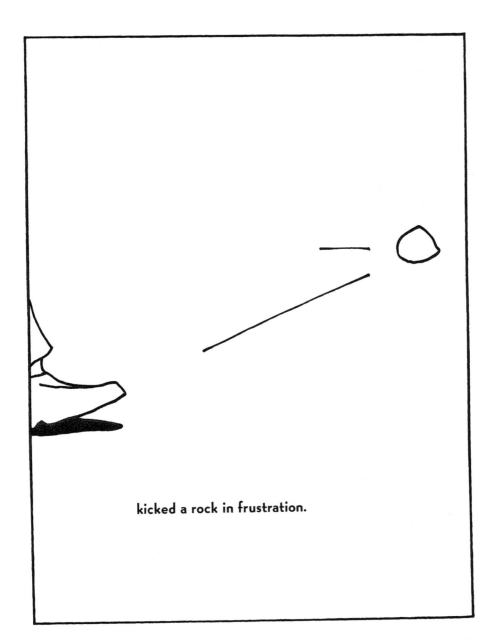

kicked a rock in frustration.

"If you want, I can tell you
where they moved it," she said.
And she bent down and

whispered the new location in
Rosemary's ear.

One plane,

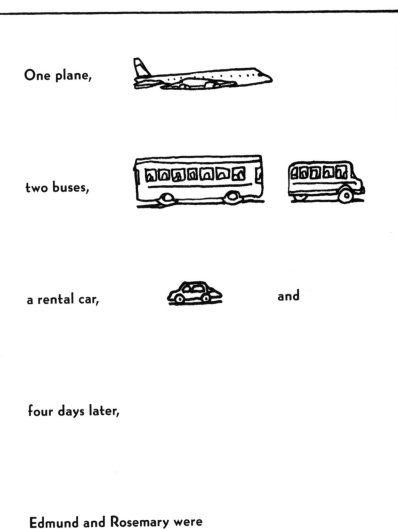

two buses,

a rental car, and

four days later,

Edmund and Rosemary were

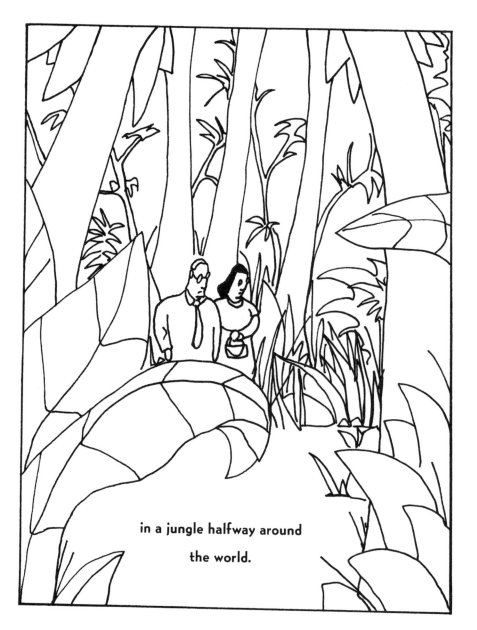

in a jungle halfway around
the world.

They spent hours searching
but once again couldn't find
what they were looking for.

Edmund kicked a vine in
frustration,

but it just lay there.
It wasn't as satisfying
as kicking a rock.

He bent down to throw the vine,

when suddenly he saw

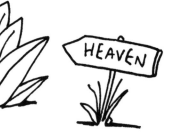

it.

He laughed
and excitedly began running
toward it. He was halfway through
when he realized that Rosemary

wasn't next to him.

He turned and saw that

she was crouching,

rummaging

through her

purse.

"What are you doing?"

Rosemary pulled out an egg salad

sandwich from yesterday and

began stuffing her face.

"I got hungry," she said.
She finished her sandwich and started
rummaging through her bag once again.

"Now what are you looking for?"

"Dessert."

She briefly considered eating a
lozenge from last winter

but thought better of it.

Edmund walked over to Rosemary.

"What's going on?"

"I'm starving," she said. "I'm
sorry, but I have to go
back to the hotel and
get a snack before
I go to Heaven."

"Are you scared?"

Rosemary didn't say
anything for a moment.

"I don't think I'm cut out for
Heaven," she said finally.
"I want to stay in Hell."

Edmund simply looked at her
in disbelief.

"Look, maybe it's all perfect up there
and we're all self-contained pieces of
energy that don't need anything or
anyone and there's eternal peace, but
I'm just not ready. I want to go
back to our room and order a
parfait."

"You don't want eternal peace?"

"It's not for me. But you go."

"I'm not going to Heaven by myself.
I don't even eat by myself."

Which was true. Edmund
refused to eat in public
by himself, even
at a counter.

"No, honestly," Rosemary said.
"You should go."

"I'm not going to Heaven if
you're not going to Heaven,"
Edmund said,
and Rosemary
knew he meant it.

She took his hand. The one
fear she had not
said out loud
was that if
they went
to Heaven,
their
relationship
might be
altered in some way.

Maybe couples weren't really couples anymore. Or perhaps you got reincarnated. What if Edmund became a coyote and Rosemary became a chicken? No, she couldn't risk losing exactly what she had now with Edmund.

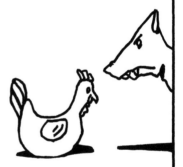

They started to walk back to the hotel.

They began talking about how it might

rain tonight and how nice it would be

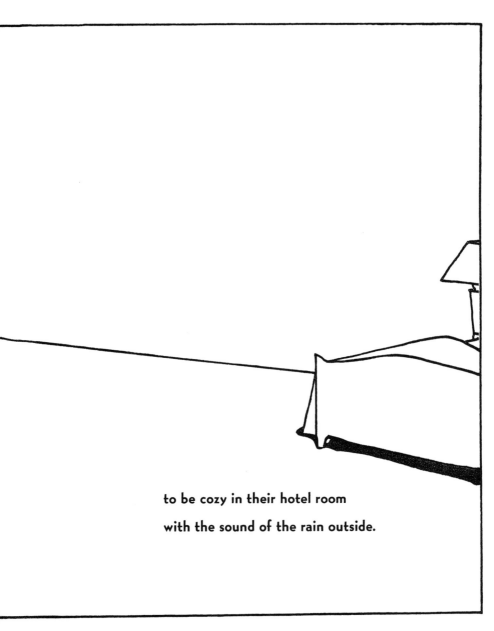

to be cozy in their hotel room

with the sound of the rain outside.

After they settled back into
their life in Brooklyn, it was
surprising how little they
talked about how they were in
Hell.

Other things kept coming up,

like the time Delia got a

mysterious illness

that thankfully went away.

Eventually they even stopped thinking

about it every now and then. Once,

Edmund almost

had the revelation

that they were

in Hell again,

as if for the

first time,

but right before

he was about

to have it,

he looked over

at Rosemary, who was reading a book,

and somehow it slipped away.

Instead he reminded her that

they were late for

something that

they had

been

looking

forward to

for a very

long

time.

BRUCE ERIC KAPLAN draws cartoons for

THE NEW YORKER, writes for television,

and is the author of four previous books,

but is still waiting to be discovered.